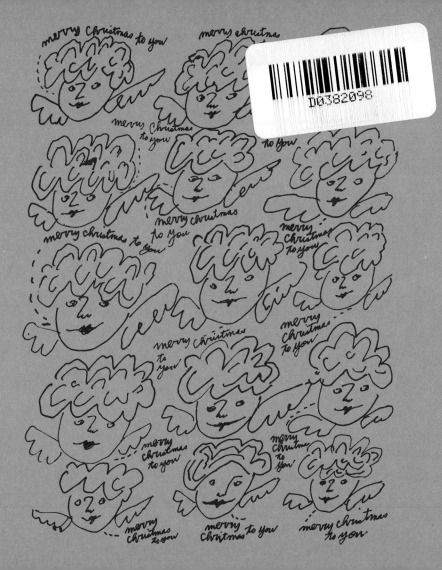

HO, HO, HO!

HO, HO, HO!

ANDY WARHOL

A BULFINCH PRESS BOOK

LITTLE, BROWN AND COMPANY BOSTON NEW YORK TORONTO LONDON

First Edition
Second Printing, 1997
Quotations from Andy Warhol compiled by R. Seth Bright
Designed by John Kane

Library of Congress Cataloging-in-Publication Data

Warhol, Andy, 1928–1987.
 Ho, ho, ho! / Andy Warhol. —1st ed.
 p. cm.
 "A Bulfinch Press Book."
 Includes bibliographical references.
 ISBN 0-8212-2193-0
 1. Warhol, Andy, 1928–1987—Themes, motives. 2. Christmas in
art. I. Title.
 NC139.W37A4 1995a
 741.973—dc20 95-996

Bulfinch Press is an imprint and trademark of
Little, Brown and Company (Inc.)
Published simultaneously in Canada by
Little, Brown & Company (Canada) Limited

PRINTED IN SINGAPORE

I could give him
a Christmas present,
a portrait of himself,

but I don't know
if it'll be done
in time.

When I was a child

I never had a fantasy about having a maid,

what I had a fantasy about having was

candy.

I would rather either have it now or know I'll never have it

so I don't have to think about it.

Anything
a person really wants
is okay with
me.

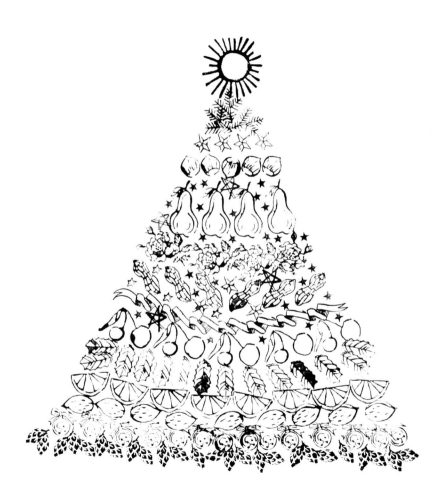

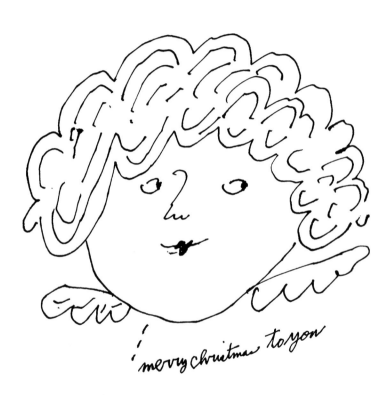

merry christmas to you

If

something's going to happen for you,

it will,

you can't make it happen.

You
can't
beat
a uniform
for glamour.

Christmas
Elf

I happen
to know

it makes me look
fabulous.

Beauty
riches
and
couldn't have
anything to do
with how **good**

you are…

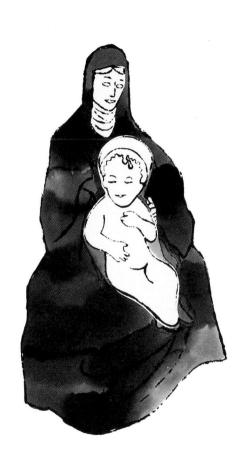

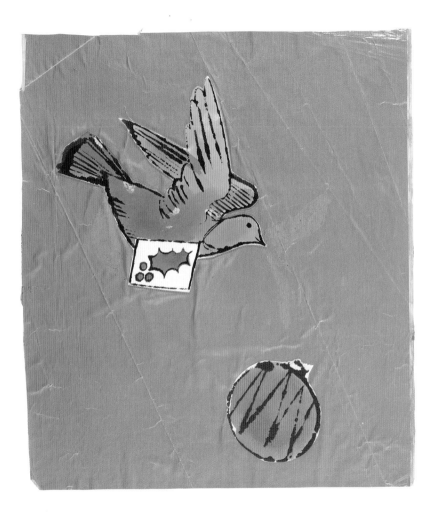

People send me

so many presents

in the mail.

I got home about 1:30

and opened my

packages.

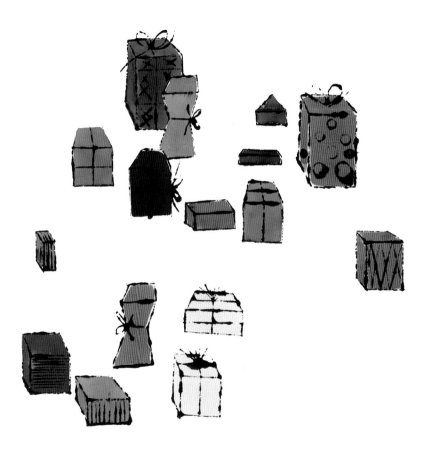

Bought another Santa Claus sculpture.

I just don't know what to paint.

I have a real

take-all-give-nothing

attitude

this year.

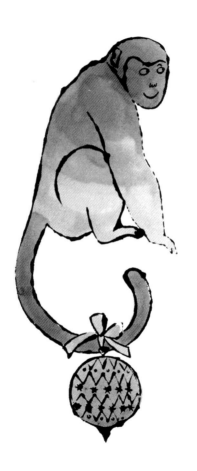

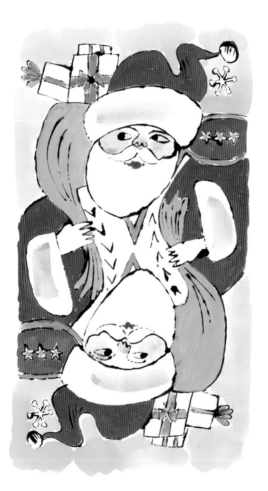

I took all day

wrapping presents.

The day after Christmas

and
I was doing

Christmas
cards
for next year.

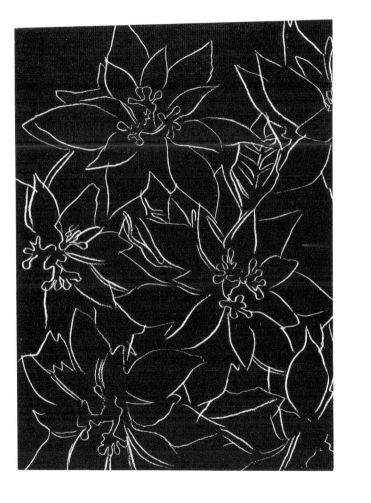

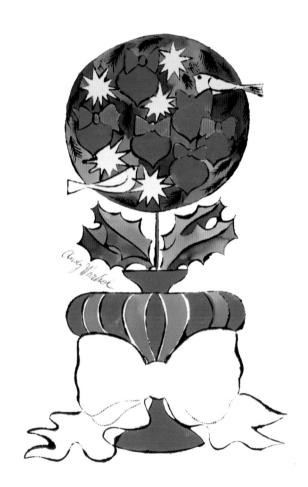

Why, this is really marvelous.

I think if they could

sing

and dance

on a subway,

they'd really enjoy it.

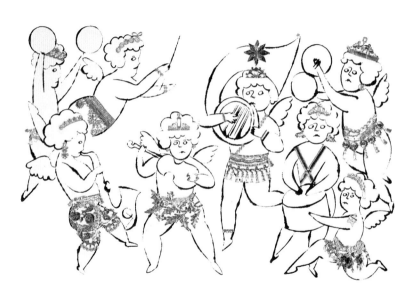

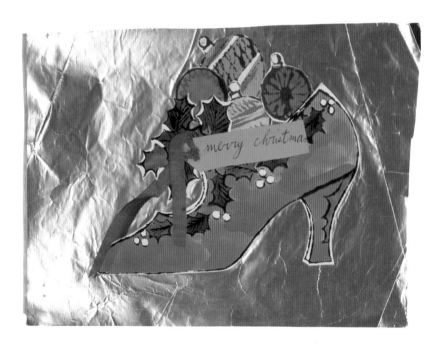

merry christmas

They know how
to look

really
grand.

Wasting money

puts
you
in

a

real party mood.

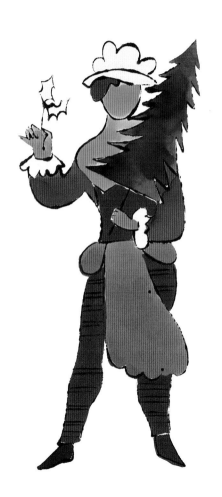

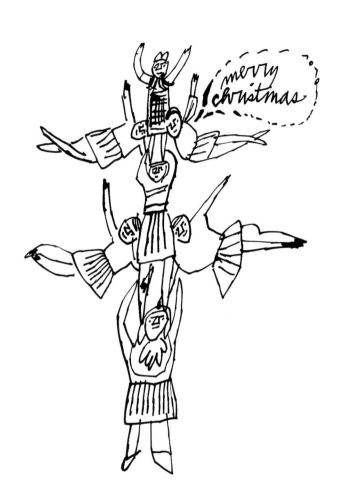

Everyone gets to mix and mingle

and you can

never guess what

combinations

you're going to see

next.

And they get to know you better

and they start to like you.

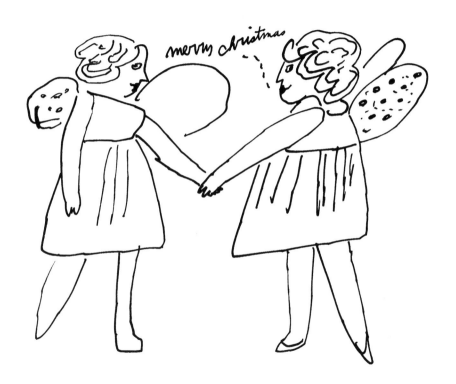

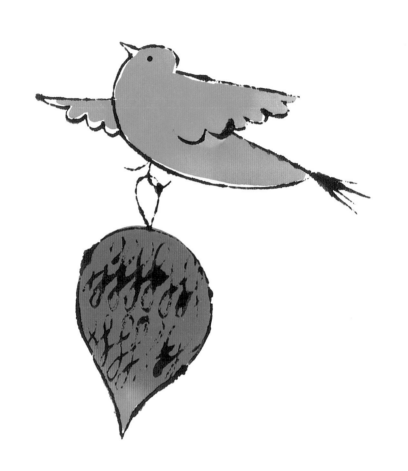

When to arrive?

I like

early.

I panic when I get there at the height of a party:

Where's
a good place to sit?

Who
do I know here?

What's
the food?

Did I miss
any good hors d'oeuvres?

How many bars
are there?

I mean sometimes you can't see over other people's heads.

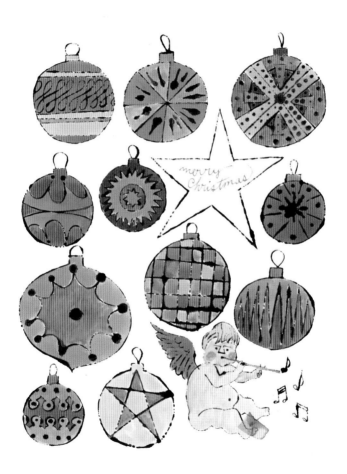

merry Christmas

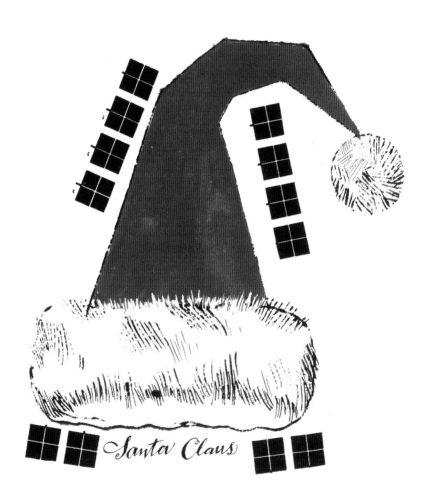

Santa Claus

The idea of
waiting for something

makes it
more exciting.

They do it all in a

big,

big

way.

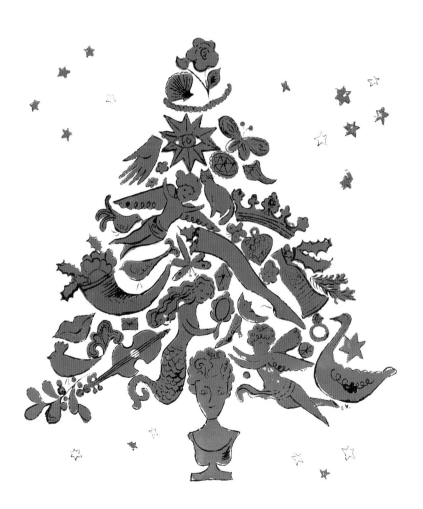

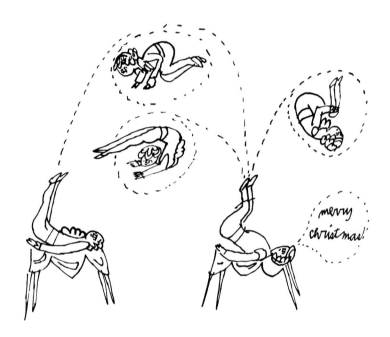

Christmas
is so

confusing.

The best kind of party

I could give
would be

champagne

and

nuts

and then take everybody dancing.

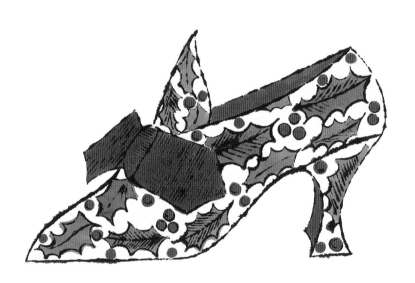

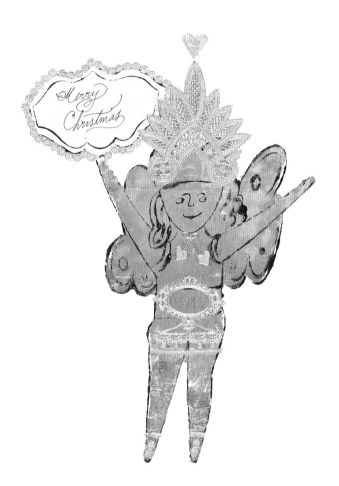

Big smiles

make a party better **because** they're

energy.

...he **finally** got in the

Christmas
spirit.

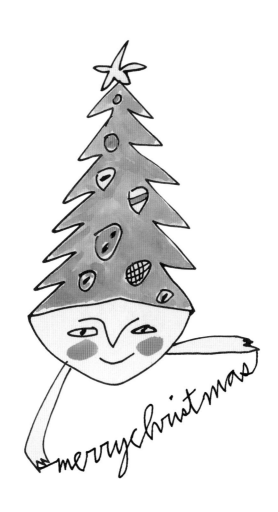

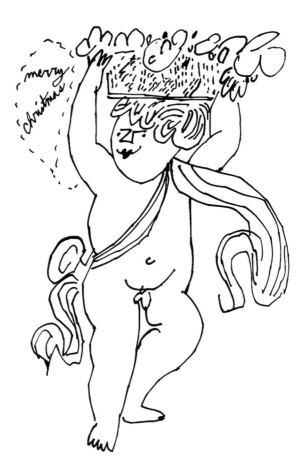

Walking home from a ball

at six o'clock in the morning

across Central Park,

in tails and a top hat,

was his idea of heaven.

More

than

anything

people

just

want

stars.

A lot of traditions

like this
are carried on…
because it takes them

out of the ordinary world
and puts them
into something…

"special."

Got a lot of calls to go
to Christmas parties
but I just decided to stay in

and I loved it.

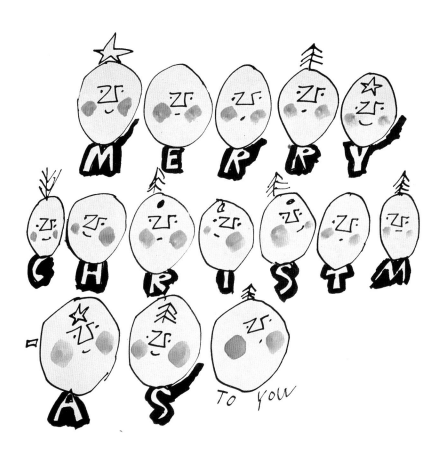

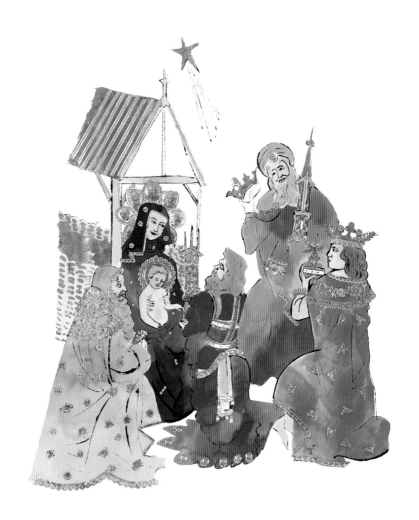

All quotations are by Andy Warhol
and were first published as follows:

Pages 8, 11, 12, 15, 20, 23, 36, 51, 56, 64:
 Andy Warhol. *The Philosophy of Andy Warhol (from A
 to B and Back Again)*. New York: Harcourt Brace
 Jovanovich, 1975.

Pages 39, 43, 44, 52:
 Andy Warhol. *America*. New York: Harper & Row, 1985.

Pages 16, 19, 40, 47, 48, 59, 63, 67:
 Andy Warhol and Pat Hackett. *Andy Warhol's Party
 Book*. New York: Crown Publishers, 1988.

Pages 7, 24, 27, 28, 31, 32, 55, 60, 68:
 Pat Hackett, Editor. *The Andy Warhol Diaries*.
 New York: Warner Books, 1989.

Page 35:
 Mike Wren. *Andy Warhol in His Own Words*.
 London: Omnibus Press, 1991.

Captions by page number

Cover
Untitled, c. 1954–58
Ink and ink wash on
Strathmore paper
29" x 23"

Endpapers
Untitled, c. 1953–54
Ink on tan paper
11 7/8" x 9"

3 Untitled, c. 1957
Offset lithograph

5 Untitled, c. 1955–58
Ink, ink wash, and acetate on
Strathmore paper
4 1/2" x 3 1/4"

6 Myths: Santa, 1981
Synthetic polymer paint and
silkscreen ink on canvas
40" x 40"
Publisher: Ronald Feldman
Fine Arts Inc.

9 Untitled, c. 1955–58
Ink and acetate on
Strathmore paper
4 5/8" x 3 3/8"

10 Untitled, c. 1957
Ink and ink wash on
Strathmore paper
12 5/8" x 17 1/4"

13 Untitled, c. 1954–58
Ink on Strathmore paper
28 5/8" x 22 5/8"

14 Untitled, c. 1953–54
Ink on tan paper
11 7/8" x 9"

17 Untitled, c. 1958
Ink and ink wash on
Strathmore paper
8 3/4" x 5"

18 Untitled, c. 1955
Ink and ink wash on
Strathmore paper
14" x 11 3/8"

21 *Untitled*, c. 1957
 Ink, ink wash, and collage on
 Strathmore paper
 12 3/4" x 11 1/2"

22 *Untitled*, c. 1957
 Ink and ink wash on collage
 on board
 11 1/4" x 10 1/8"

25 *Untitled*, c. 1953–54
 Ink and ink wash on
 Strathmore paper
 12 1/2" x 11 1/2"

26 *Myths: Santa (36 times)*, 1981
 Synthetic polymer paint and
 silkscreen ink on canvas
 60" x 60"
 Publisher: Ronald Feldman
 Fine Arts Inc.

29 *Untitled*, c. 1957
 Ink and ink wash on
 Strathmore paper
 15 1/2" x 11 1/2"

30 *Untitled*, c. 1957
 Ink and ink wash on
 Strathmore paper
 22 1/2" x 14 1/4"

33 *Poinsettias*, c. 1982
 Synthetic polymer paint and
 silkscreen ink on canvas
 27" x 20"

34 *Untitled*, c. 1957
 Ink and ink wash on
 Strathmore paper
 22 5/8" x 14 3/8"

37 *Untitled*, c. 1955
 Stamped gold collage and
 ink on Strathmore paper
 22 1/2" x 28 1/2"

38 *Untitled*, c. 1957
 Ink and ink wash on
 Strathmore paper and
 gold paper
 9 1/8" x 12 1/2"

41 *Untitled*, c. 1957
Ink and ink wash on
Strathmore paper
22 7/8" x 14 3/4"

42 *Untitled*, c. 1951–54
Ink on white bond paper
11" x 8 1/2"

45 *Untitled*, 1951–54
Ink on pink paper
8 1/2" x 11"

46 *Untitled*, c. 1957
Ink and ink wash on
Strathmore paper
14 1/8" x 12 7/8"

49 *Untitled*, c. 1953–55
Graphite, ink, and ink wash
on Strathmore paper
22 1/2" x 14 1/2"

50 *Untitled*, c. 1958
Ink and ink wash on
Strathmore paper
7 5/8" x 6 3/4"

53 *Untitled*, c. 1957
Printed in gold
12 7/8" x 9 3/4"

54 *Untitled*, c. 1951–54
Ink on white bond paper
8 1/2" x 11"

57 *Untitled*, c. 1955–58
Offset lithograph and
watercolor on paper

58 *Untitled*, c. 1955
Gold leaf, ink, and stamped
gold collage on Strathmore
paper
23" x 14 1/4"

61 *Untitled*, c. 1953–54
Ink and tempera on
manila bond paper
11" x 8 1/2"

62 *Untitled*, c. 1953–54
Ink on white bond paper
11" x 8 1/2"

65 *Untitled*, c. 1954–58
Gold leaf, ink, ink wash, and
stamped gold on Strathmore
paper
16 1/4" x 14 3/4"

66 *Untitled*, c. 1958
Ink and ink wash on
Strathmore paper
22 5/8" x 13 3/4"

69 *Untitled*, c. 1951–54
Ink and watercolor on ivory
bond paper
11 1/4" x 8 3/8"

70 *Untitled*, c. 1957
Gold leaf, stamped gold
collage, ink, and ink wash on
Strathmore paper
29" x 22 7/8"

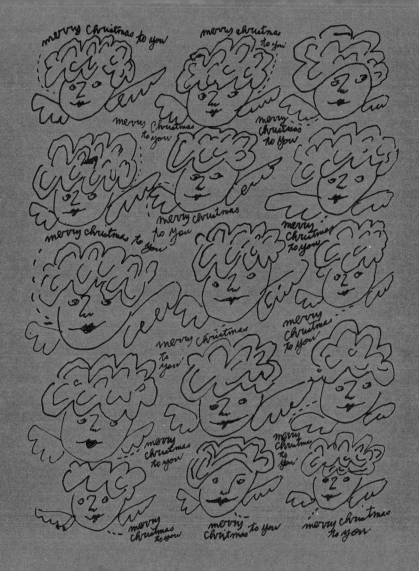